T0199059

AuthorHouse™ UK
1663 Liberty Drive
Bloomington, IN 47403 USA
www.authorhouse.co.uk
UK TFN: 0800 0148641 (Toll Free inside the UK)
UK Local: 02036 956322 (+44 20 3695 6322 from outside the UK)

This book is printed on acid-free paper.

ISBN: 978-1-6655-9123-2 (sc)
978-1-6655-9122-5 (e)

Print information available on the last page.

Published by AuthorHouse 07/22/2021

authorHOUSE®

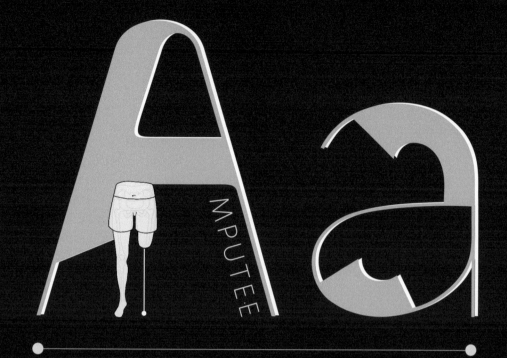

A·a
M·P·U·T·E·E

الكِفاية
ENOUGH

Published by: Dalal Elsamannoudi

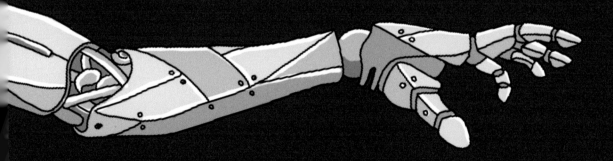

Let the
journey
begin.

CONTENTS

"WHY FIT IN WHEN YOU WERE
BORN TO STAND OUT?"

—DR. SEUSS

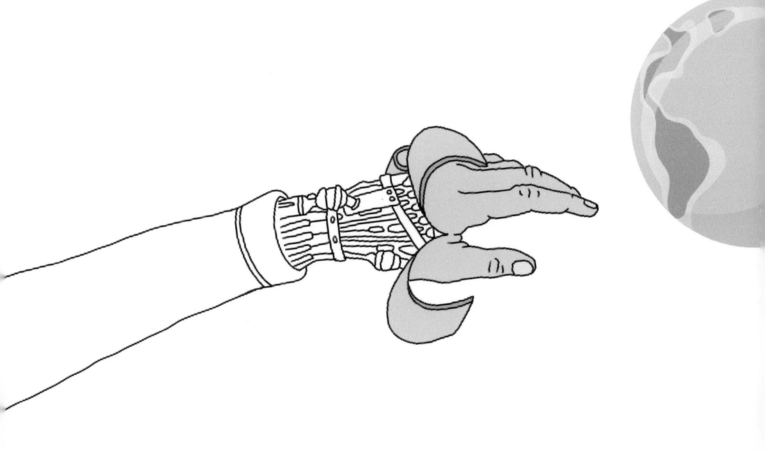

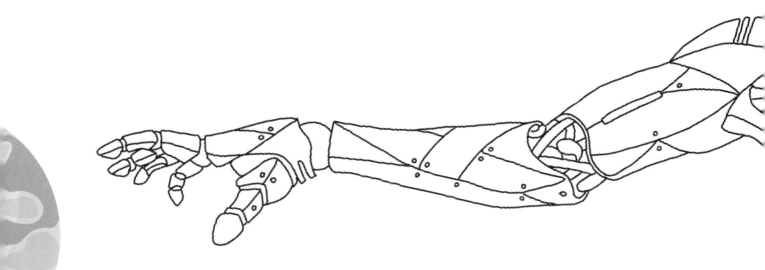

TYPEFACE NARRATIVE

This type specimen book represents a newly generated typeface that incorporates the movement of prosthetic limbs in its font. It uses the power of art to elicit change in raising social awareness for amputees, providing them with a voice and an identity that will impact their way of living and capacitate them to stand out and communicate their message globally.

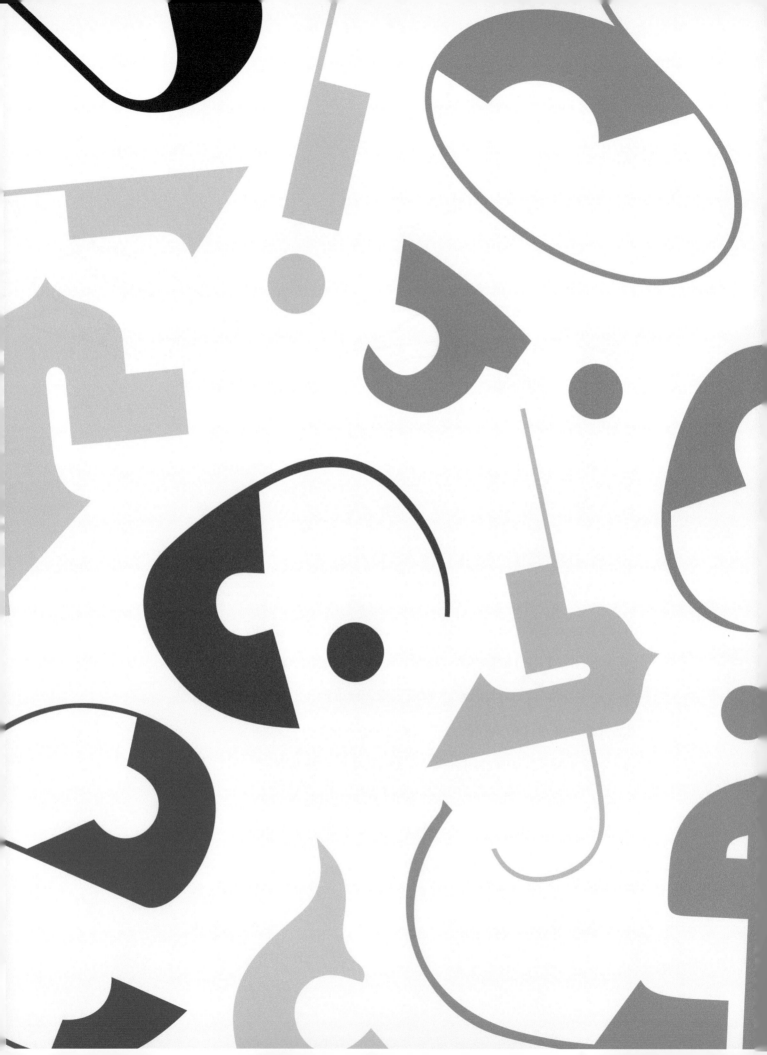

Al-ke-fĀ-ya

1. a state of feeling competent, worthy, or content
2. the condition or feeling of being satiated or filled; fullness

- adequacy, contentedness, contentment, satisfaction, sufficiency, enough

A B C D

E F G H

I J K L

M N O P

Q R S T

U V W X

Y a n d Z

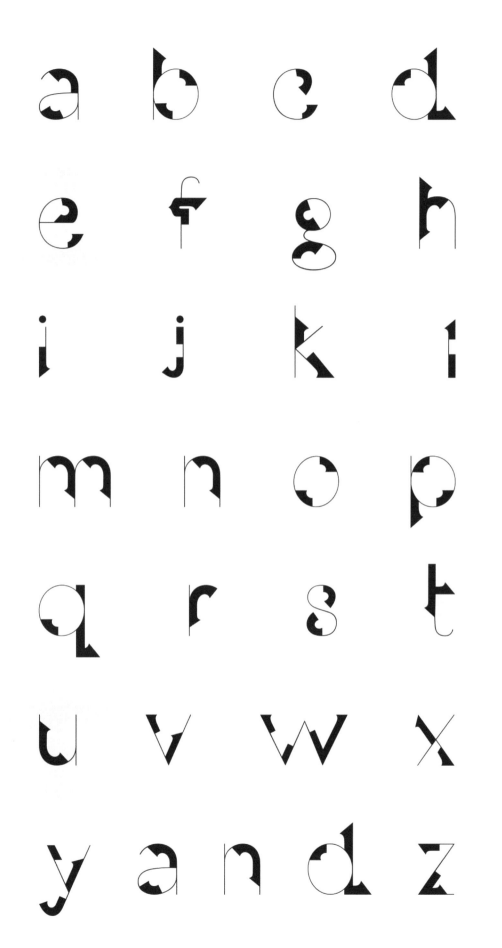

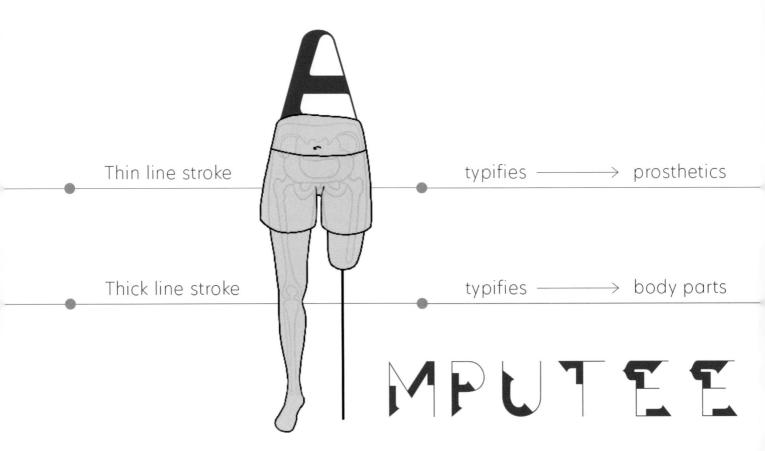

Thin line stroke

typifies ⟶ prosthetics

Thick line stroke

typifies ⟶ body parts

MPUTEE

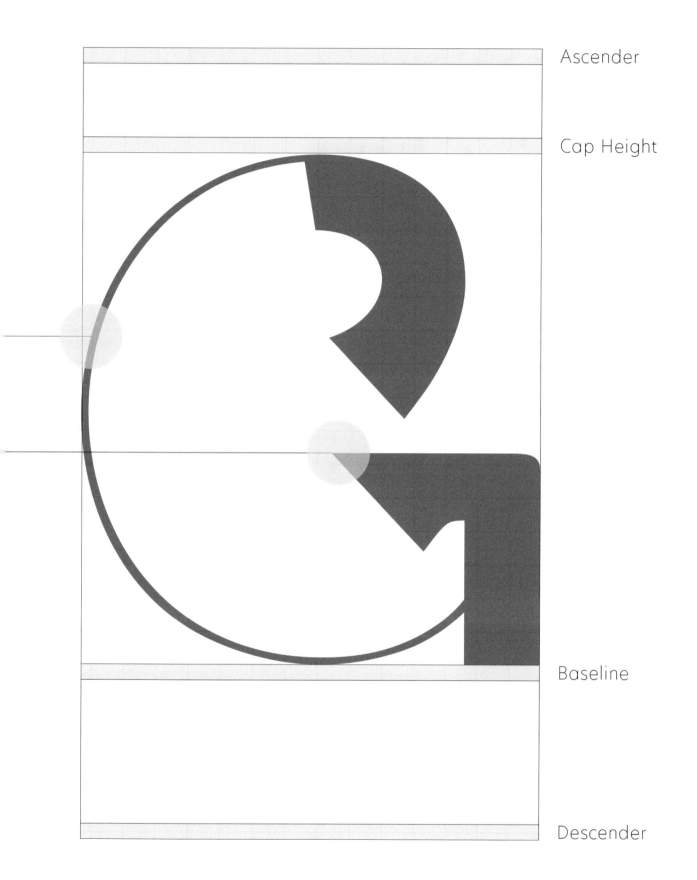

Ascender

Cap Height

Baseline

Descender

Prosthetics 18. pts

Prosthetics 24. pts

Prosthetics 28. pts

Prosthetics 34. pts

Prosthetics 38. pts

Prosthetics 44. pts

Prosthetics 48. pts

Prosthetics 54. pts

Not less than thirty points
As BIG as possible

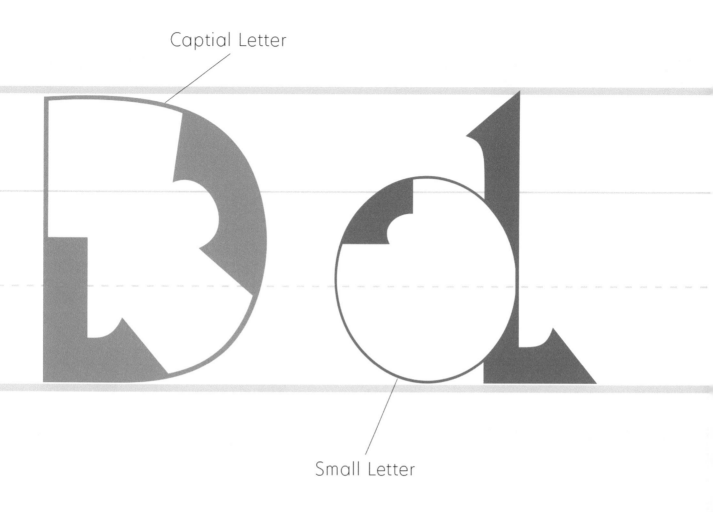

Captial Letter

Small Letter

DIMENSIONS

Every font reaches a size limit of accessibility and readability. The font Alkefaya starts at 30 points and ends with infinity. Due to the thin line strokes, the smaller the font gets, the less receptive it becomes. Thus this unique type perfectly suits posters, billboards, vehicles, and large commodities.

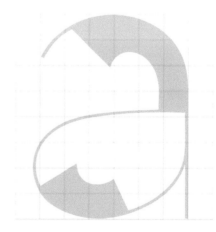

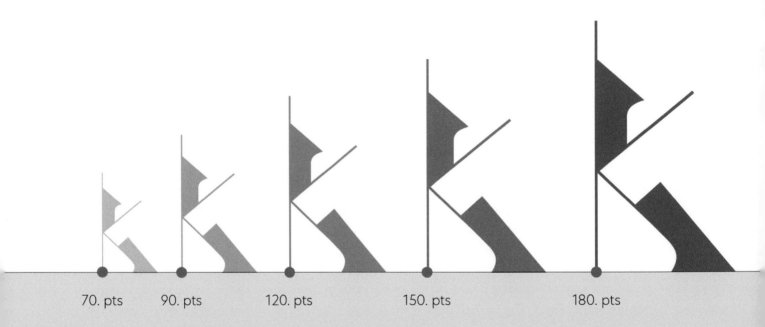

70. pts 90. pts 120. pts 150. pts 180. pts

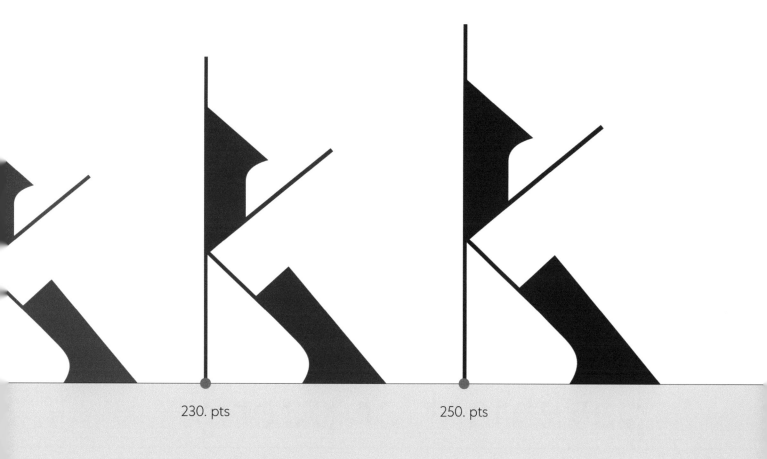

230. pts 250. pts

For people
with limited
mobility potential
environmental
barriers include not
only physical and
structural barriers
such as uneven
pavement or poorly
lighted areas but
also societal and
psychological barriers
such as discrimination
and attitudes

YOU ARE ENOUGH...

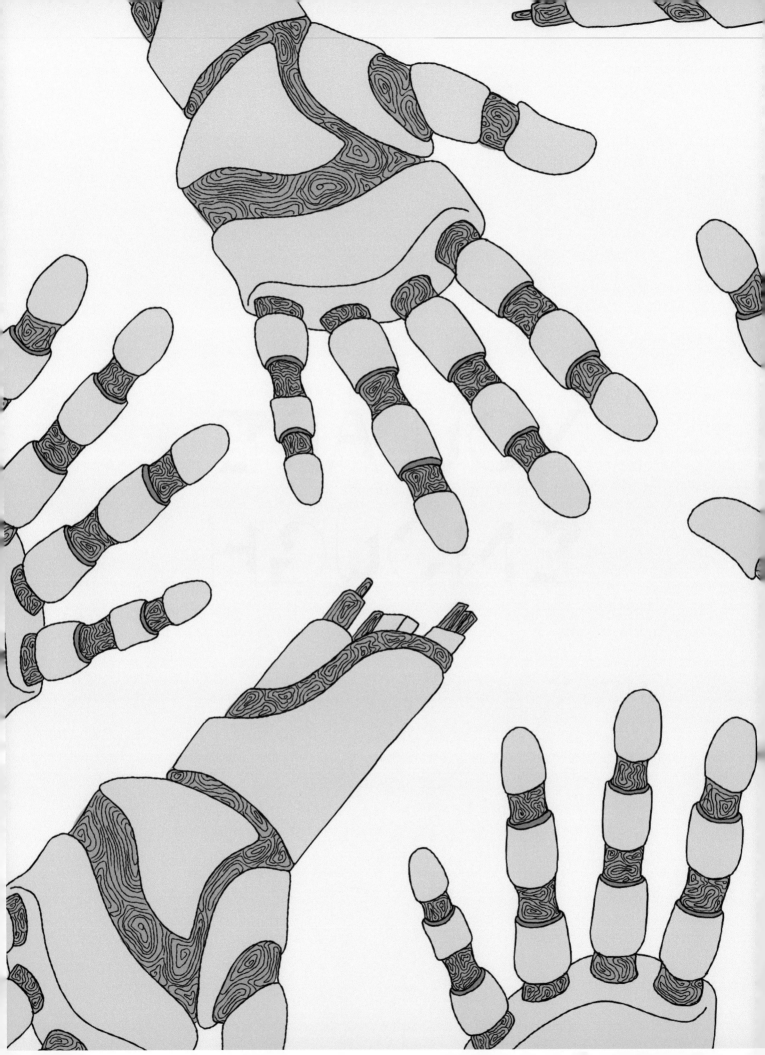

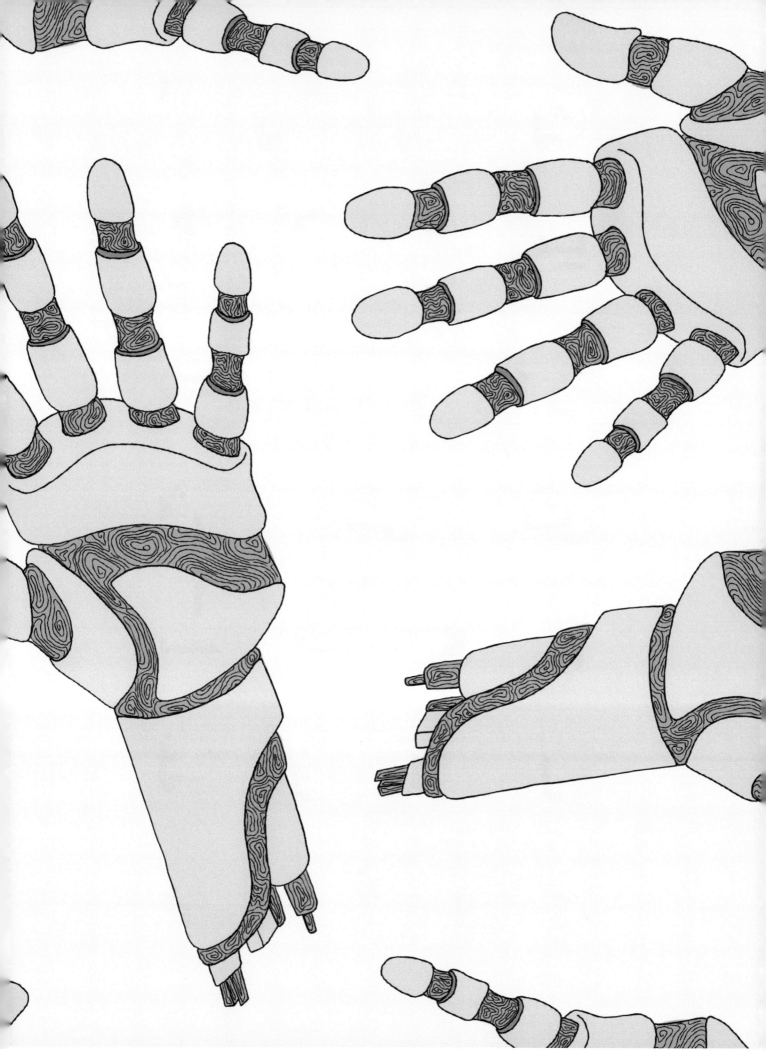

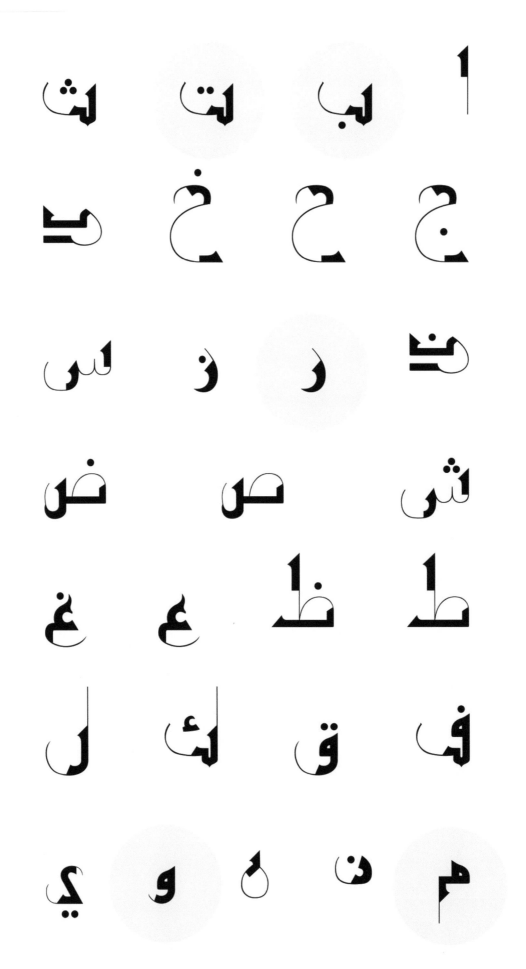

ا

ث ت ب

ج ح خ

د ذ ر ز س

ش ص ض

ط ظ ع غ

ف ق ك ل

م ن و ي

16

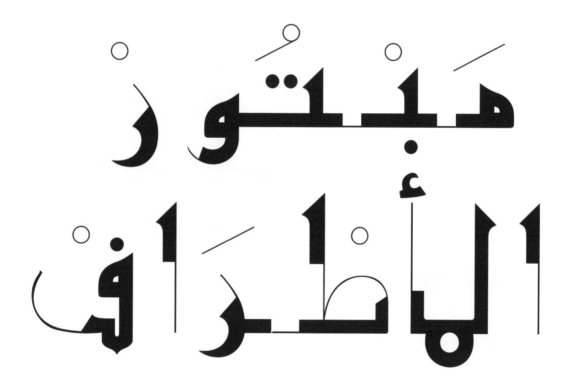

مبتور الأطراف

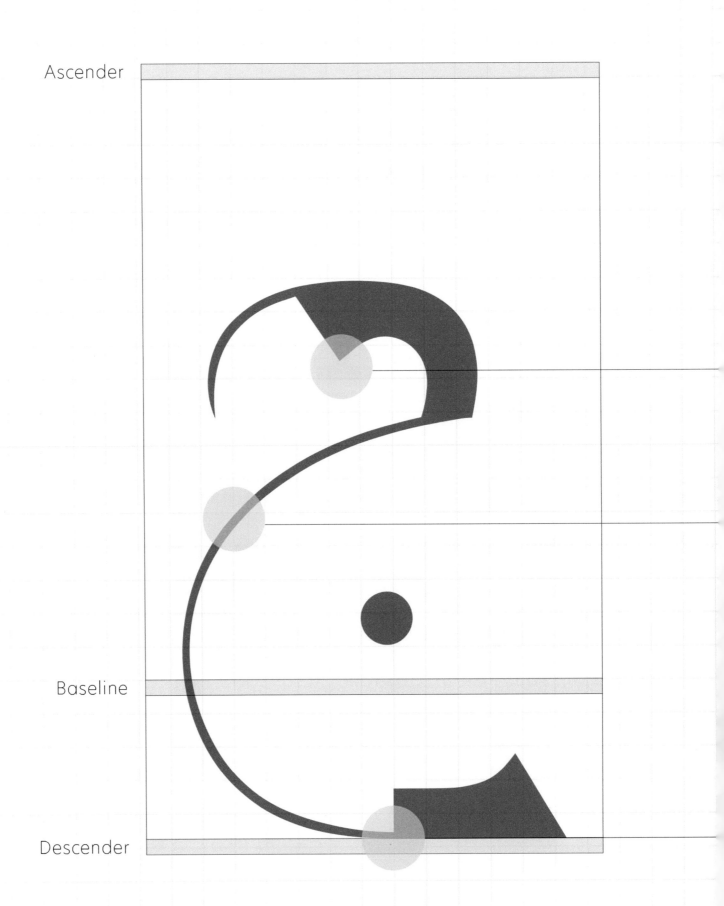

Ascender

Baseline

Descender

18

Diwan Kufi ديوان كوفي

OmnesArabic ام نيس العربي

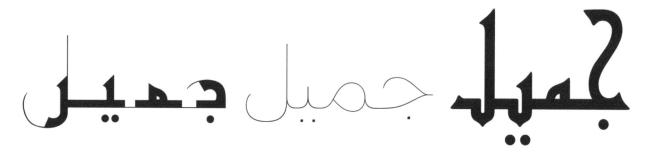

جميل جميل جميل

Ikefaya الكفاية

Tawwab

Jami'a

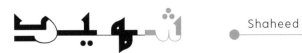

Shaheed

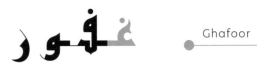

Ghafoor

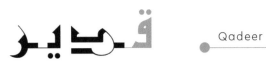

Qadeer

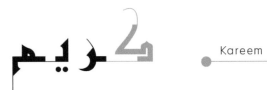

Kareem

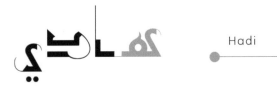

Hadi

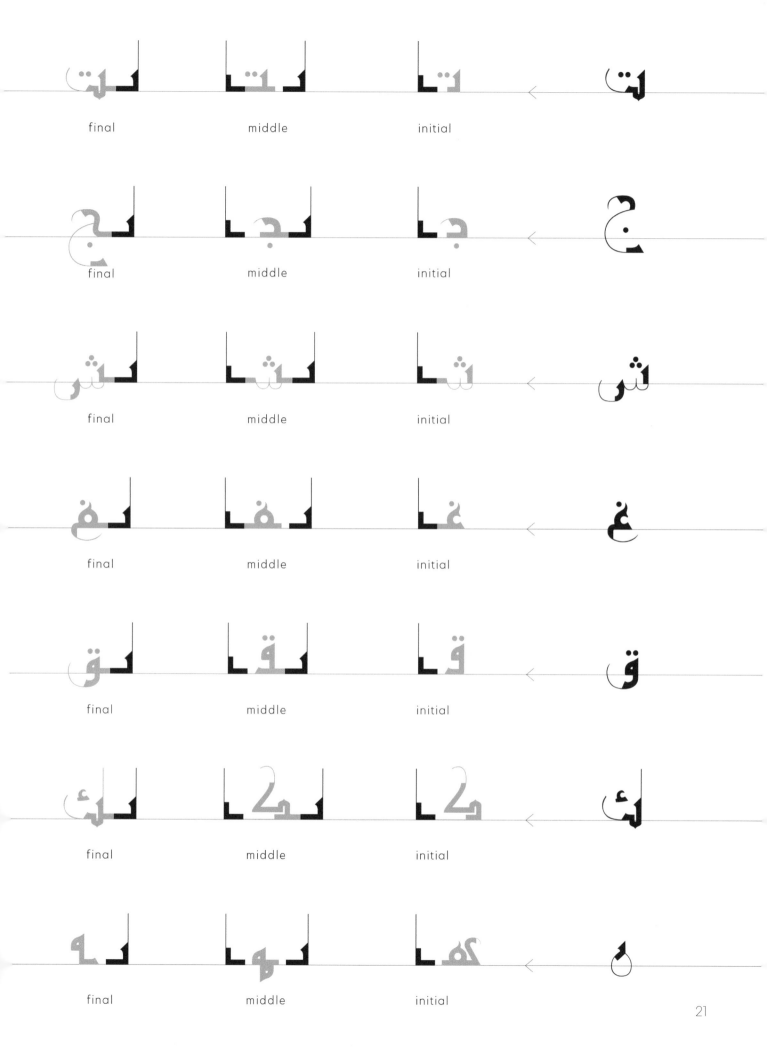

final	middle	initial	
final	middle	initial	
final	middle	initial	
final	middle	initial	
final	middle	initial	
final	middle	initial	
final	middle	initial	

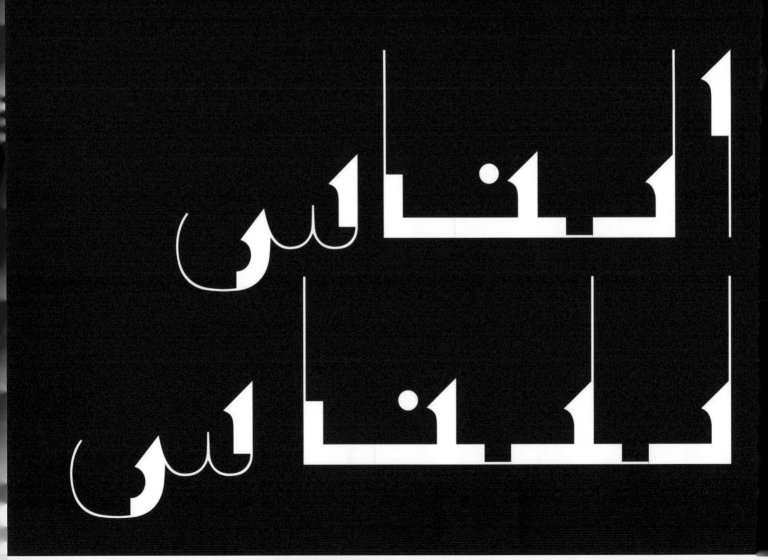

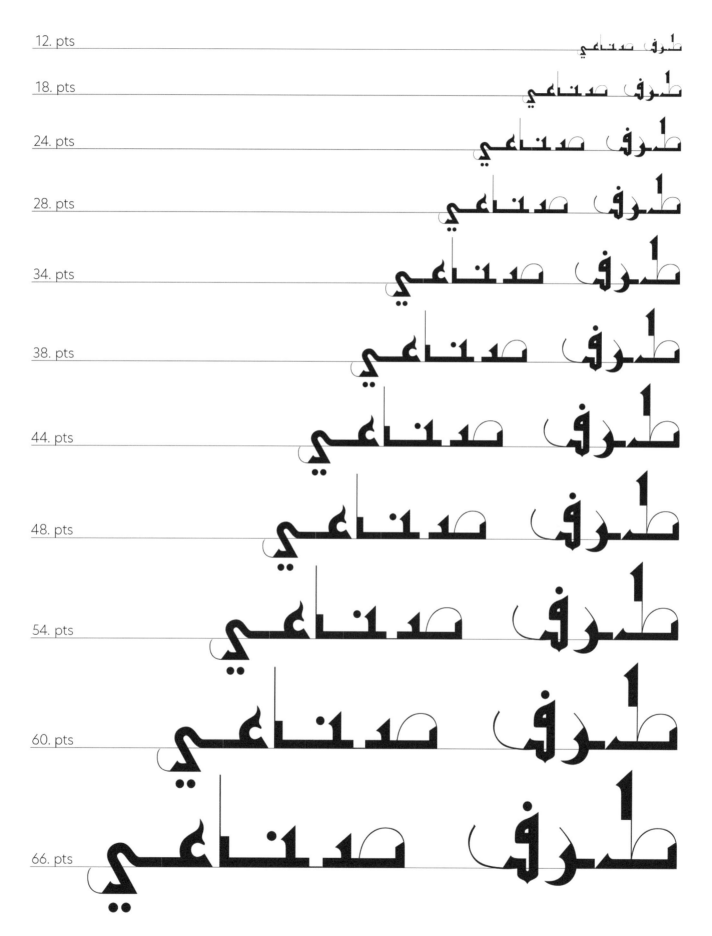

12. pts

18. pts

24. pts

28. pts

34. pts

38. pts

44. pts

48. pts

54. pts

60. pts

66. pts

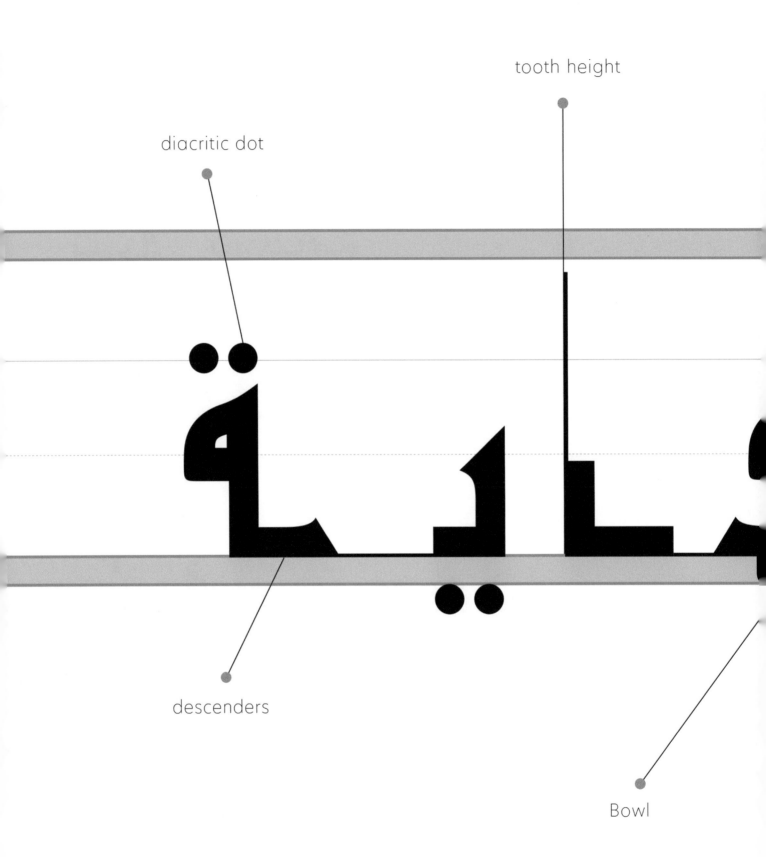

tooth height

diacritic dot

descenders

Bowl

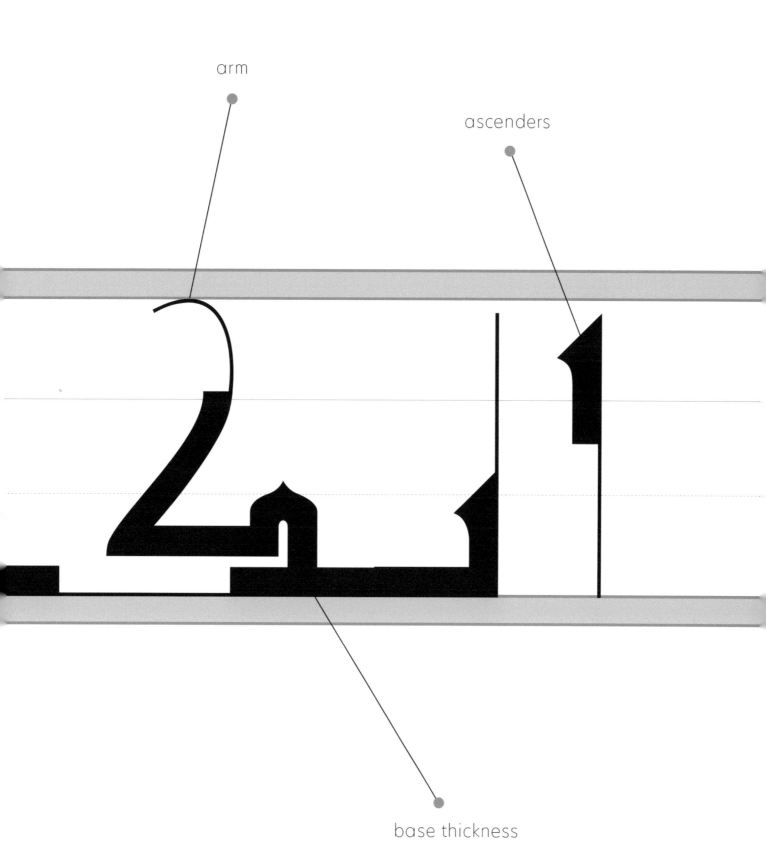

arm

ascenders

base thickness

د	خ	ح	ج
daal	khaa'	haa'	jiim

ط	ض	ص	ش
taa'	daad	saad	shinn

م	ل	ﻚﺌ	ق
miim	laam	kaaf	qaaf

		ء	ے
		hamza	alf maqsora

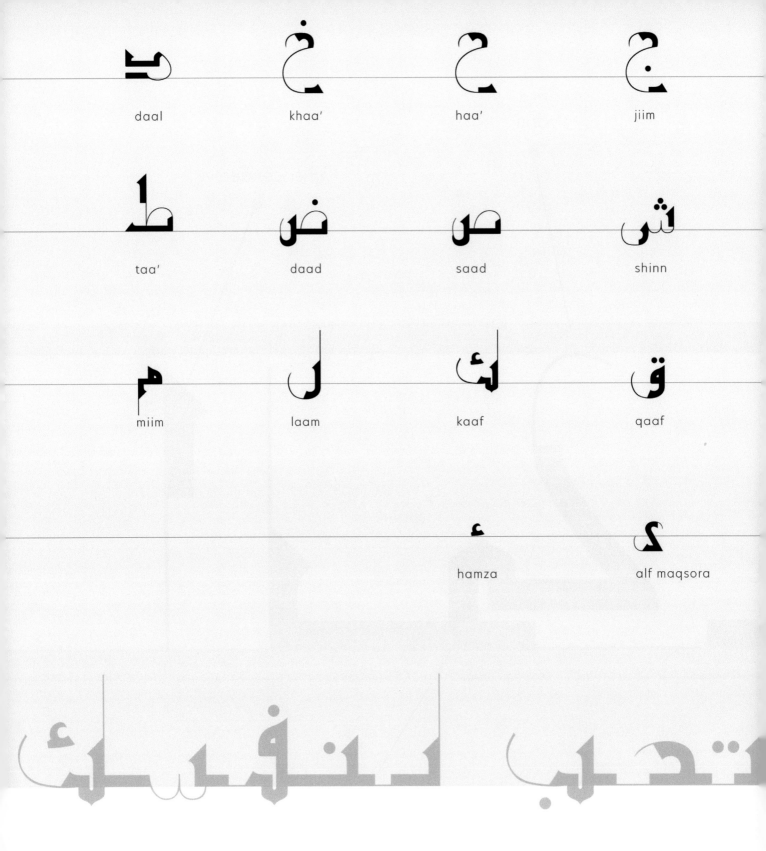

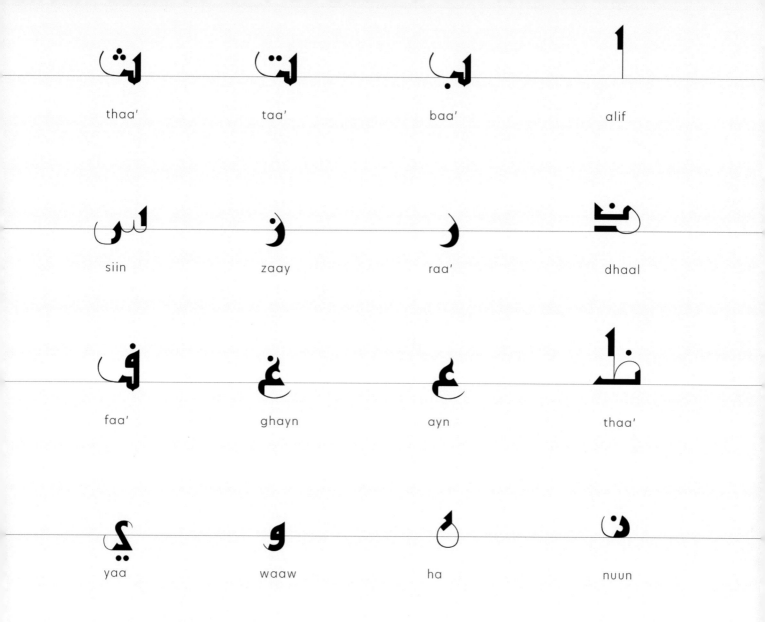

thaa'	taa'	baa'	alif
ث	ت	ب	١

siin	zaay	raa'	dhaal
س	ز	ر	ذ

faa'	ghayn	ayn	thaa'
ف	غ	ع	ظ

yaa	waaw	ha	nuun
ي	و	ه	ن

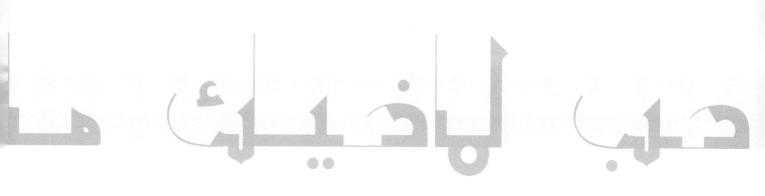

PS

Your value doesn't decrease based on someone's inability to see your worth.

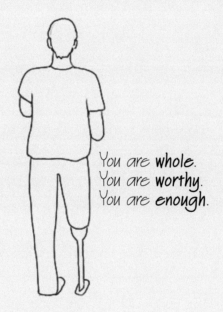

You are **whole**.
You are **worthy**.
You are **enough**.

Printed in the United States
by Baker & Taylor Publisher Services